SNOOPY

COLORING BOOK

COPYRIGHT © 2020 - ALL RIGHTS RESERVED.

THIS BOOK BELONGS TO

COLOR TEST PAGE

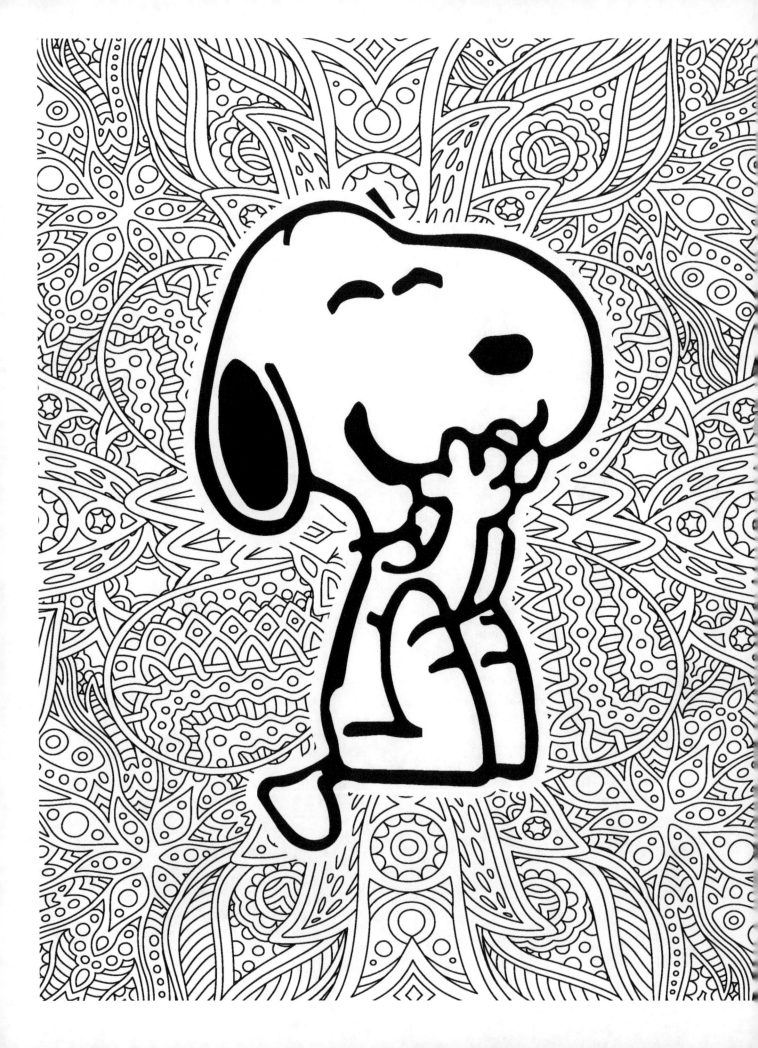

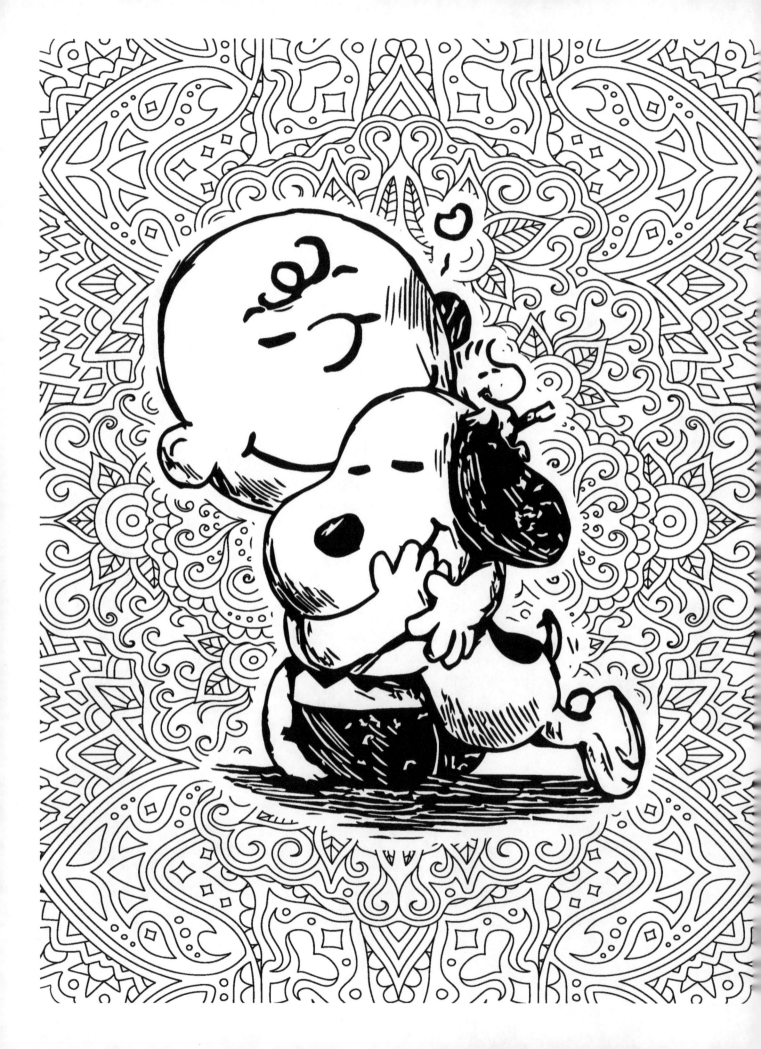

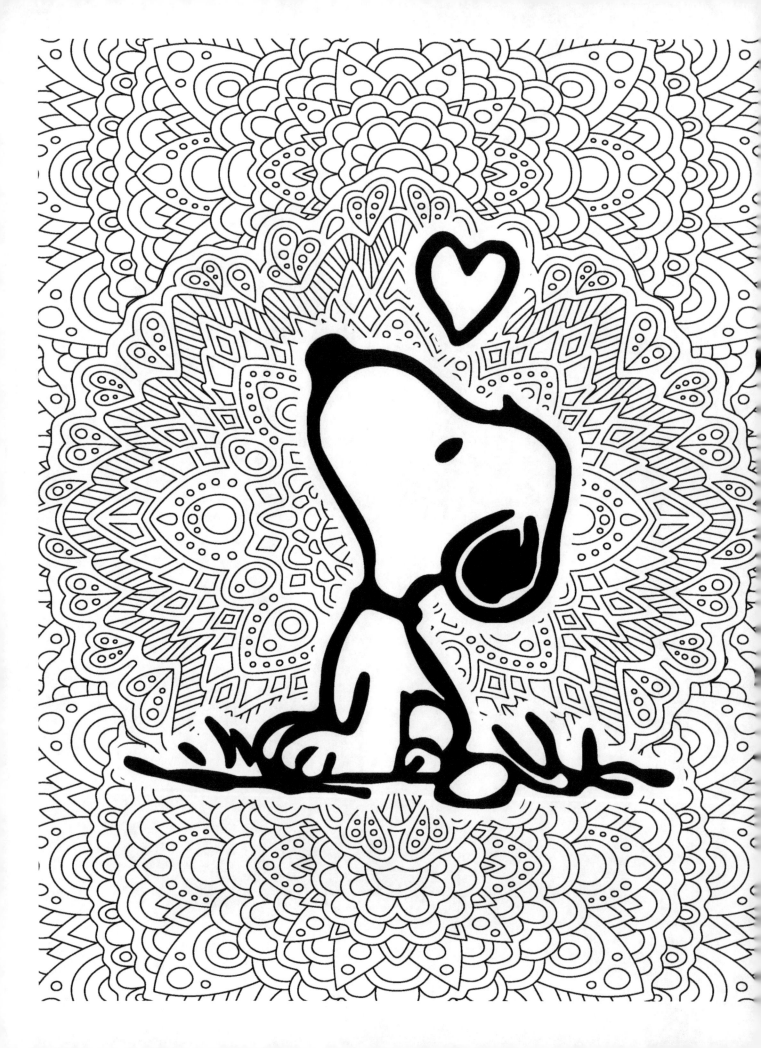

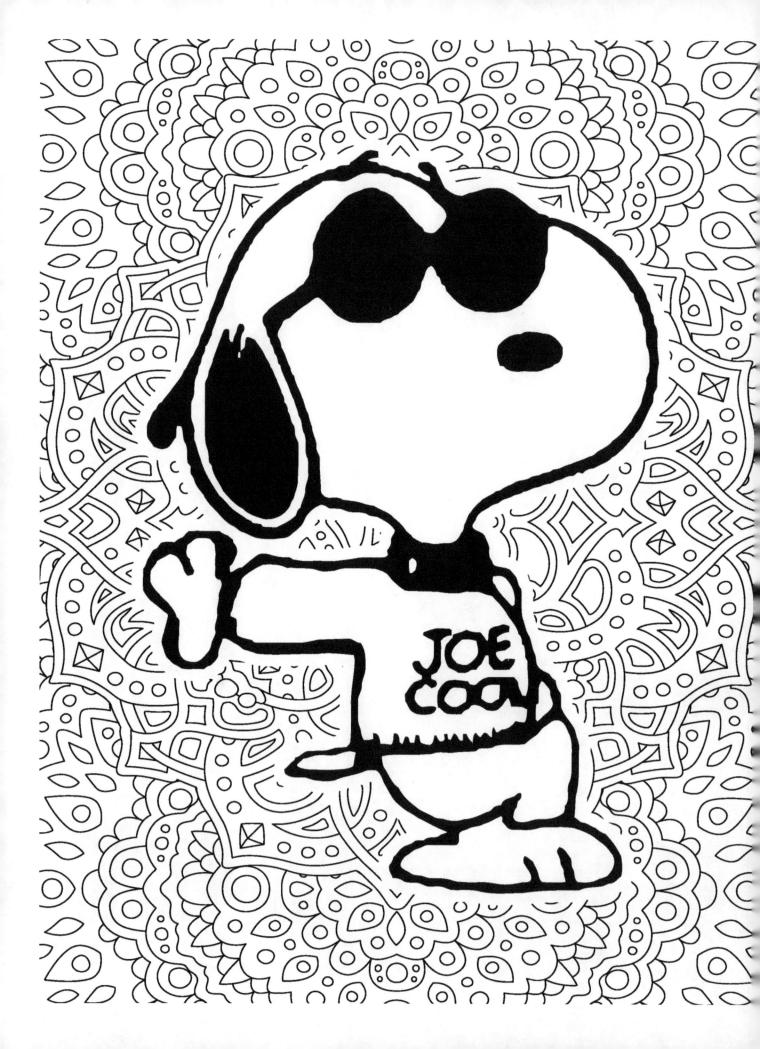

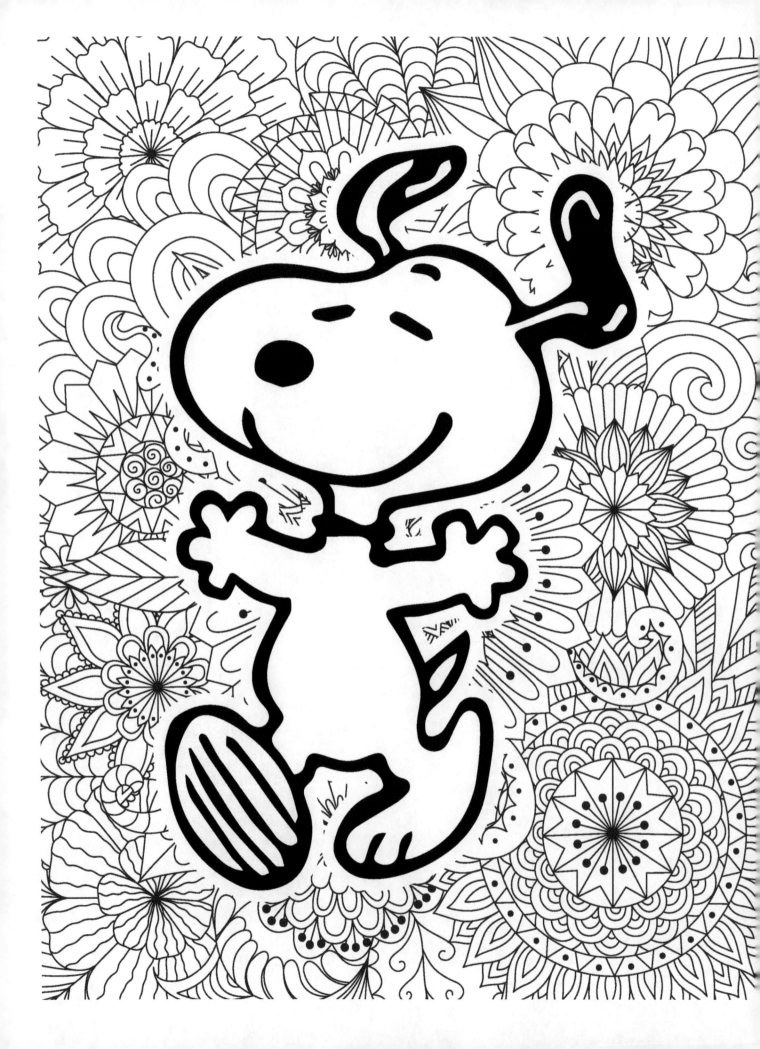

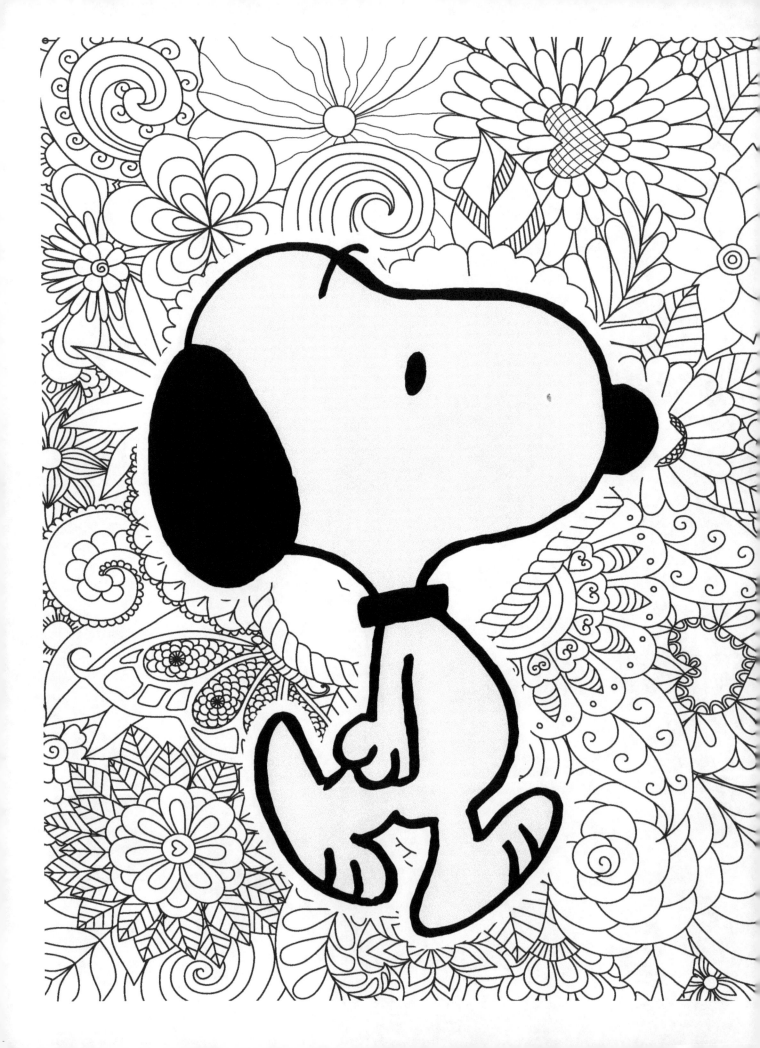

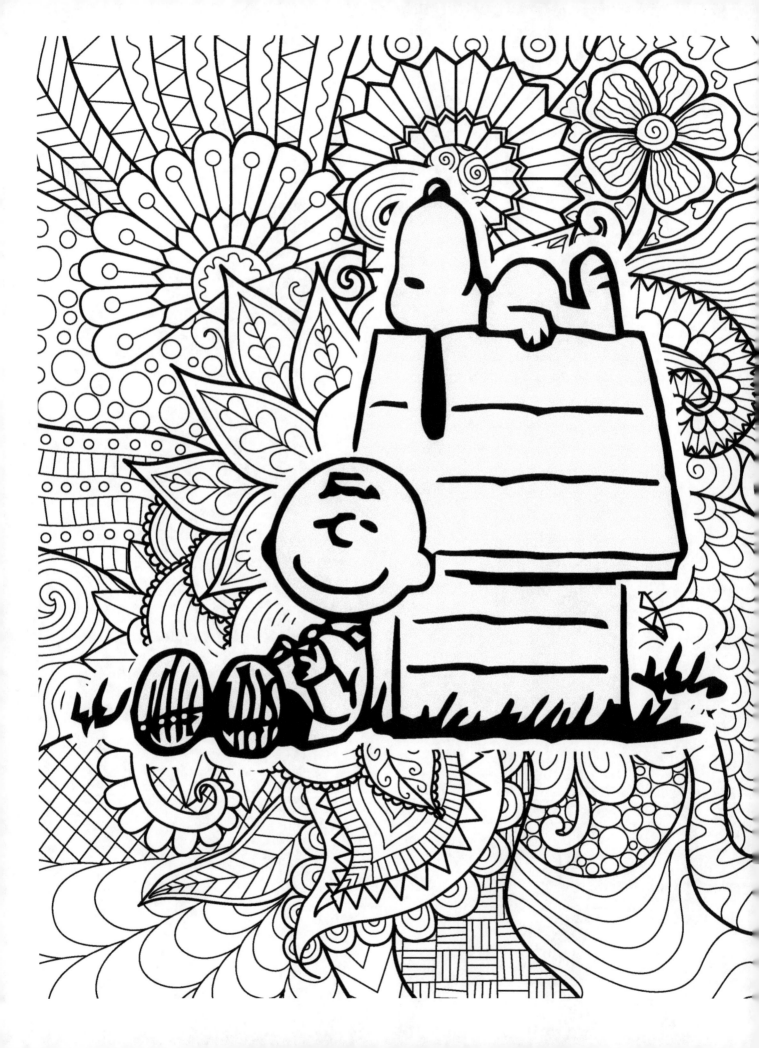

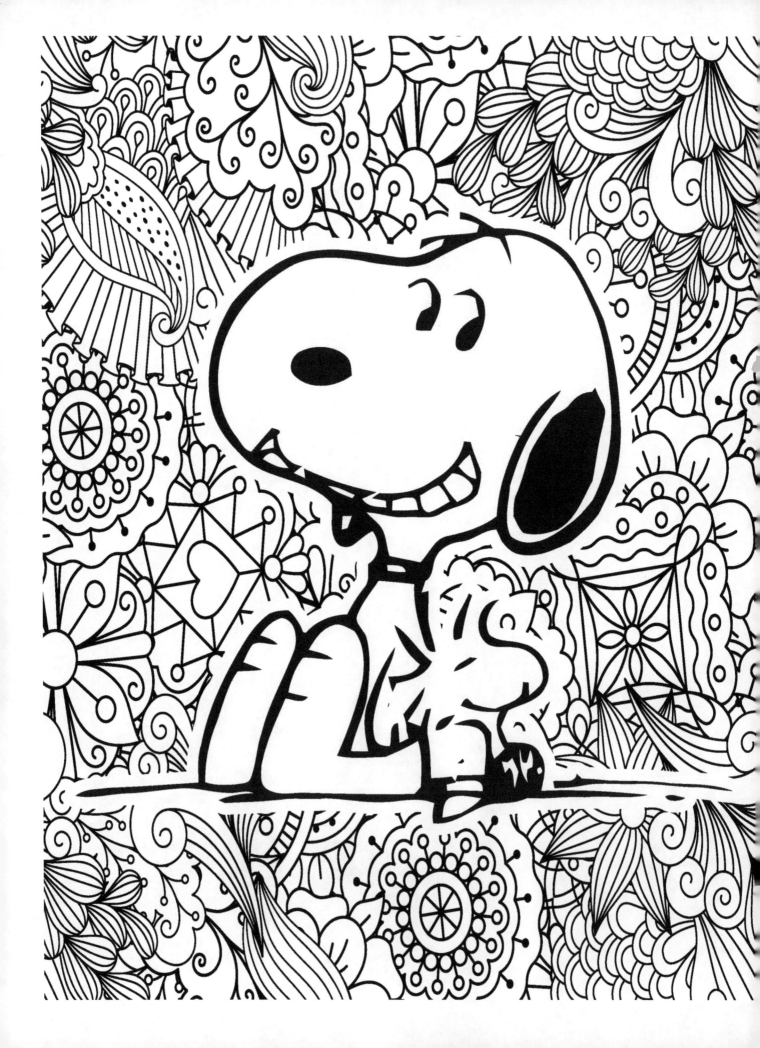

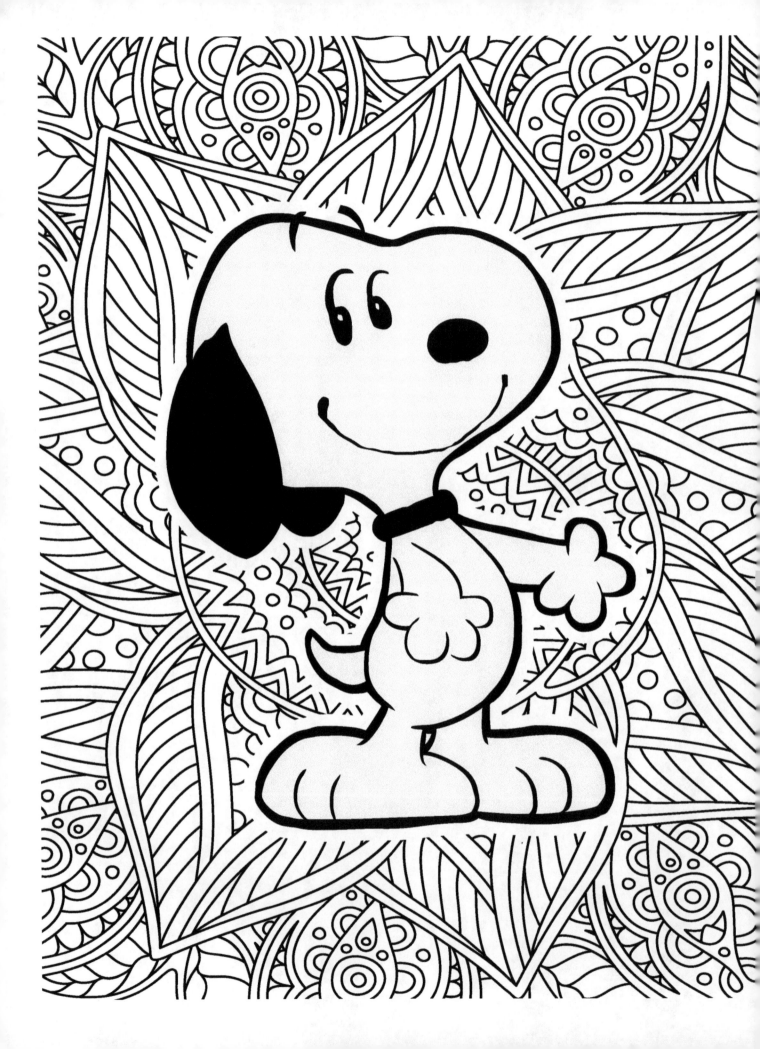

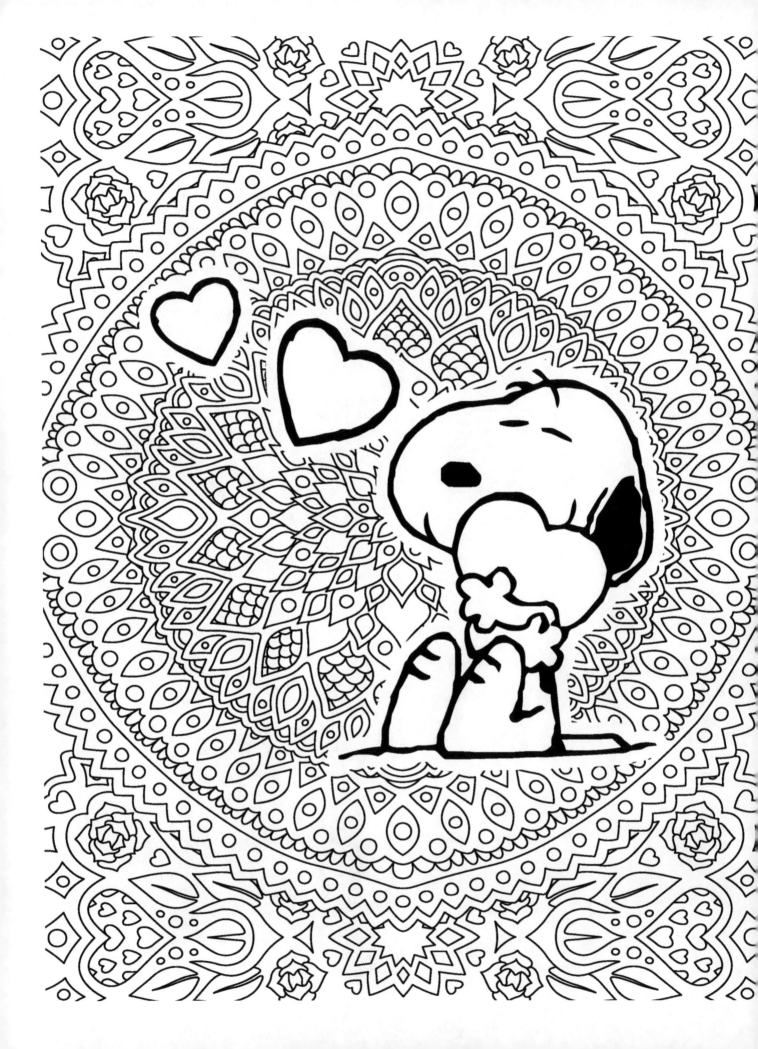

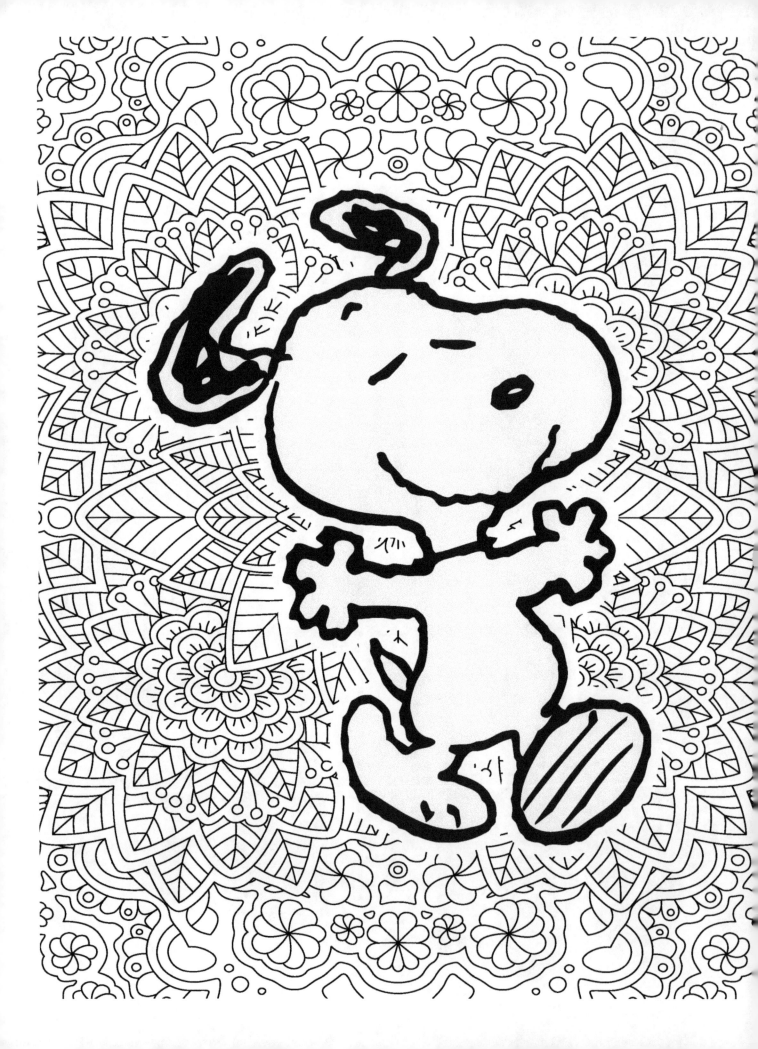

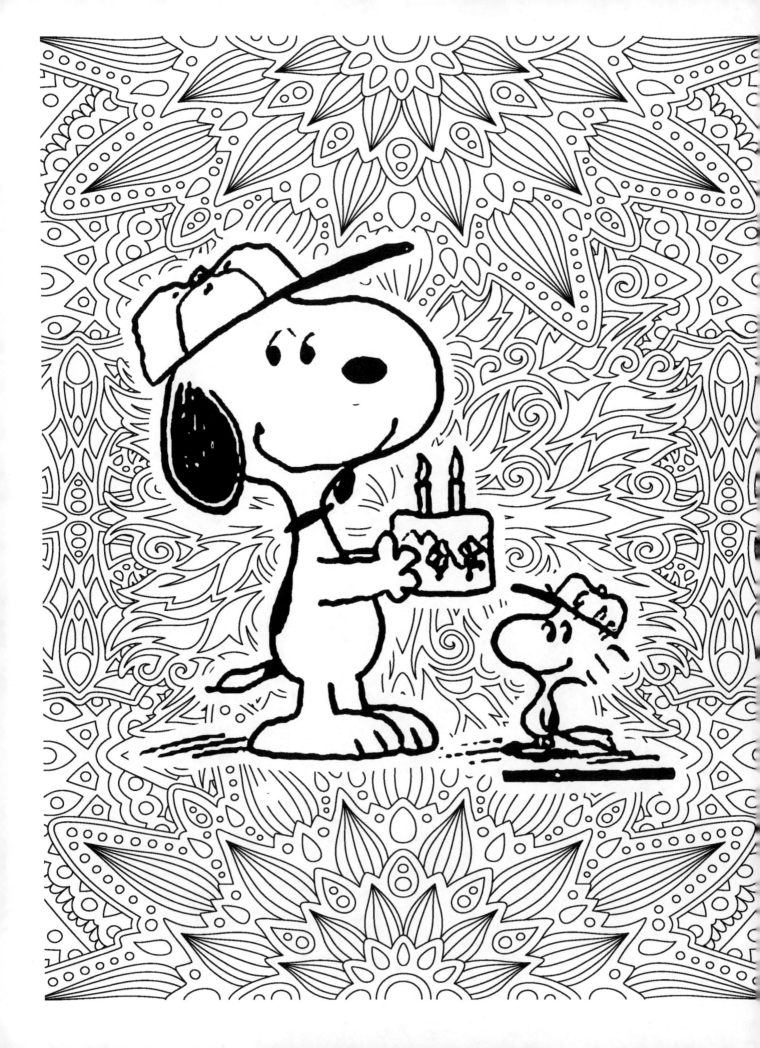

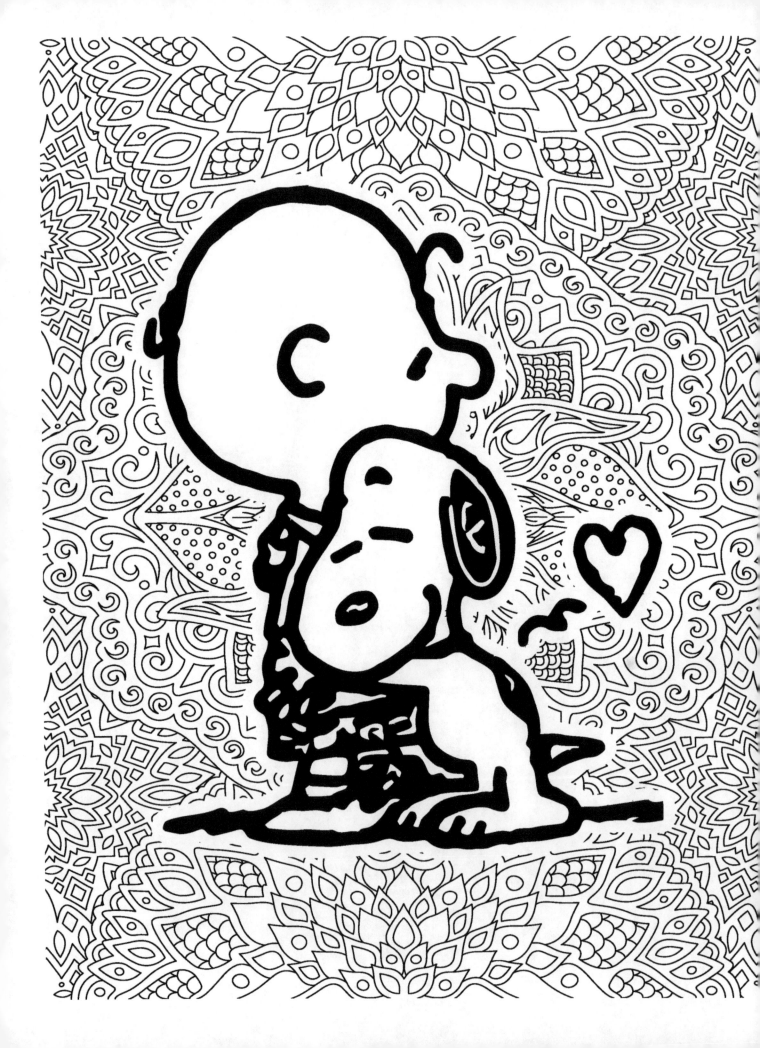

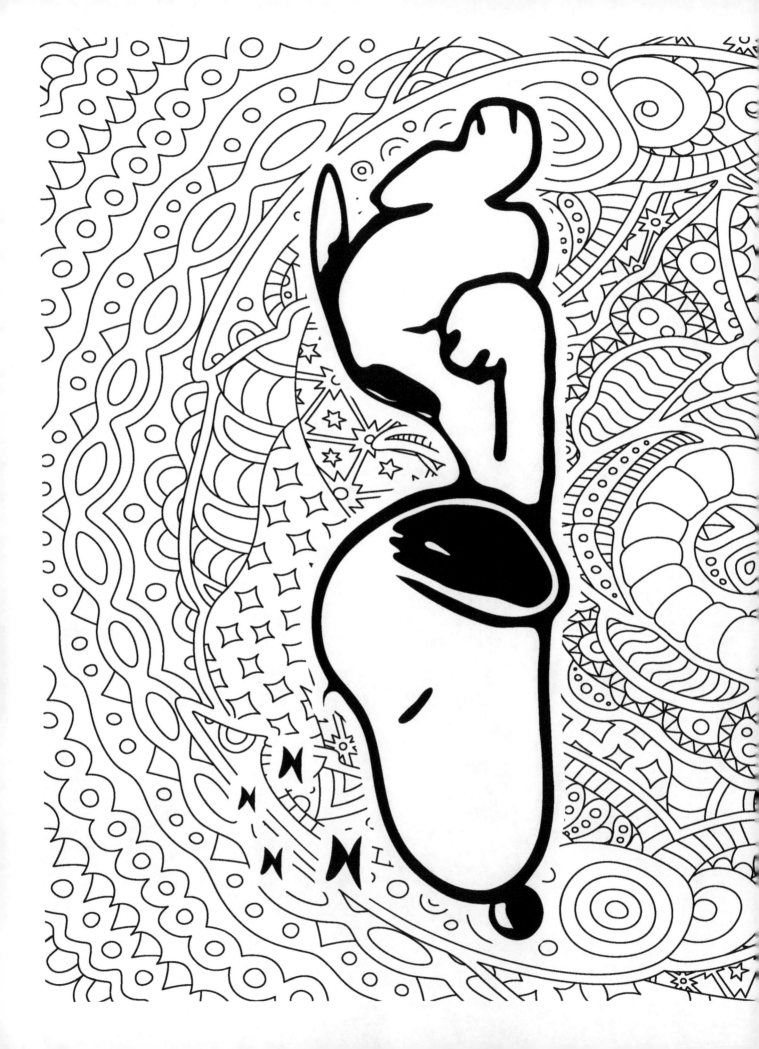

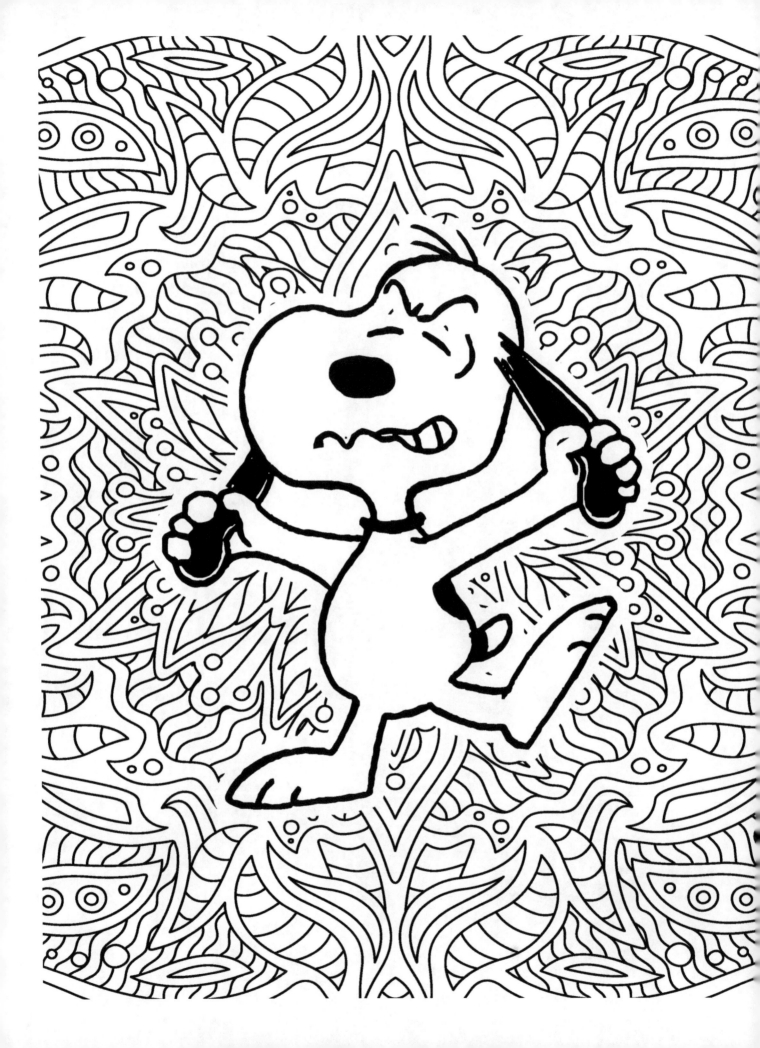

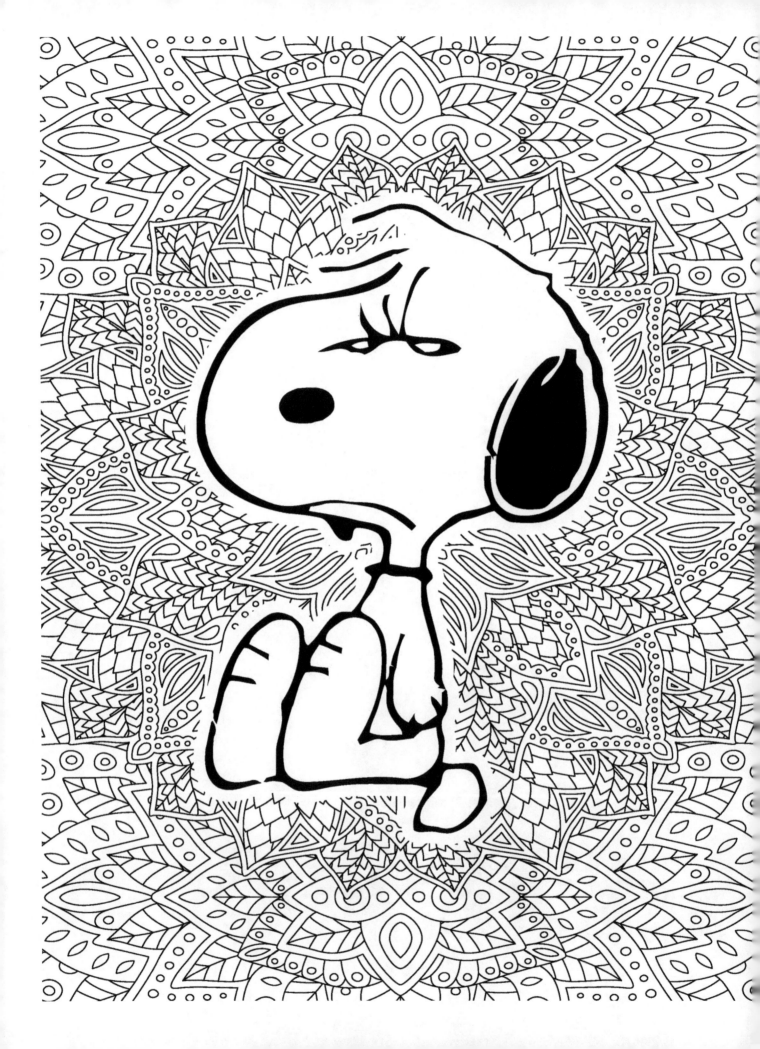

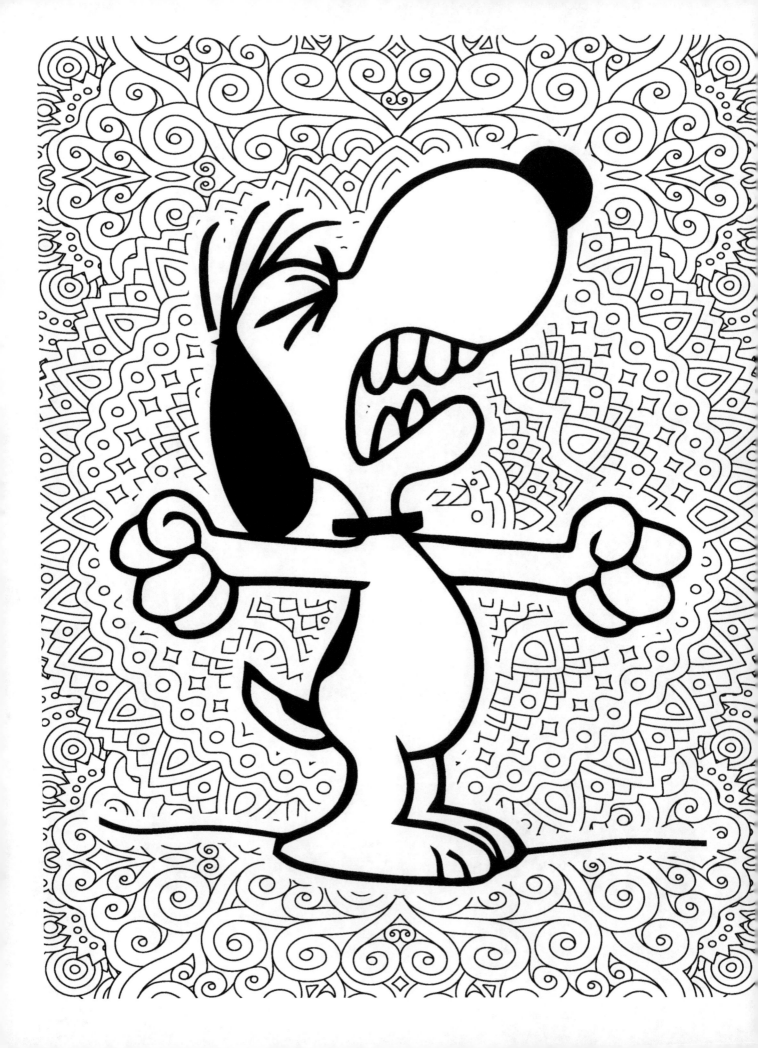

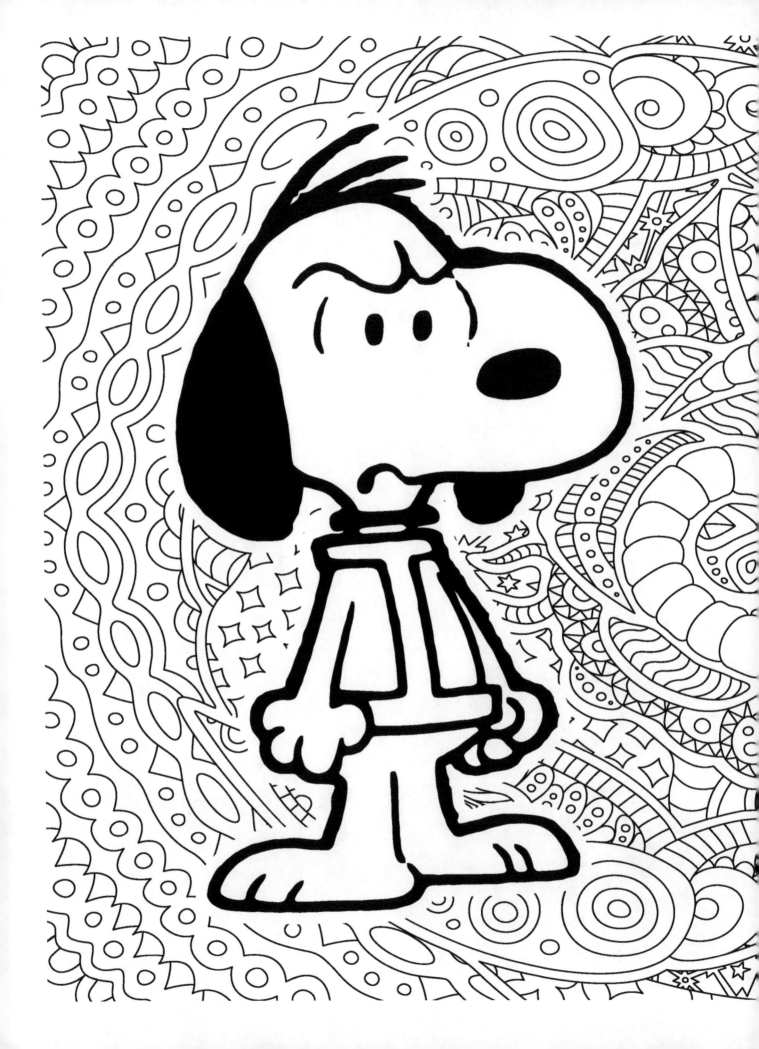

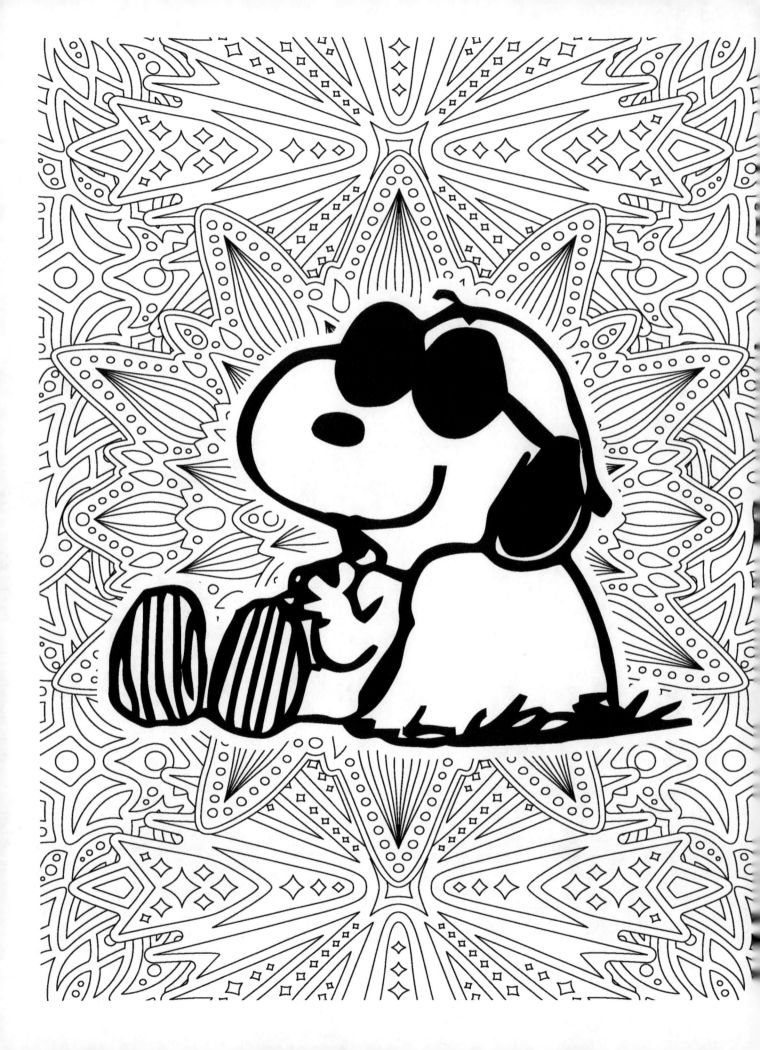

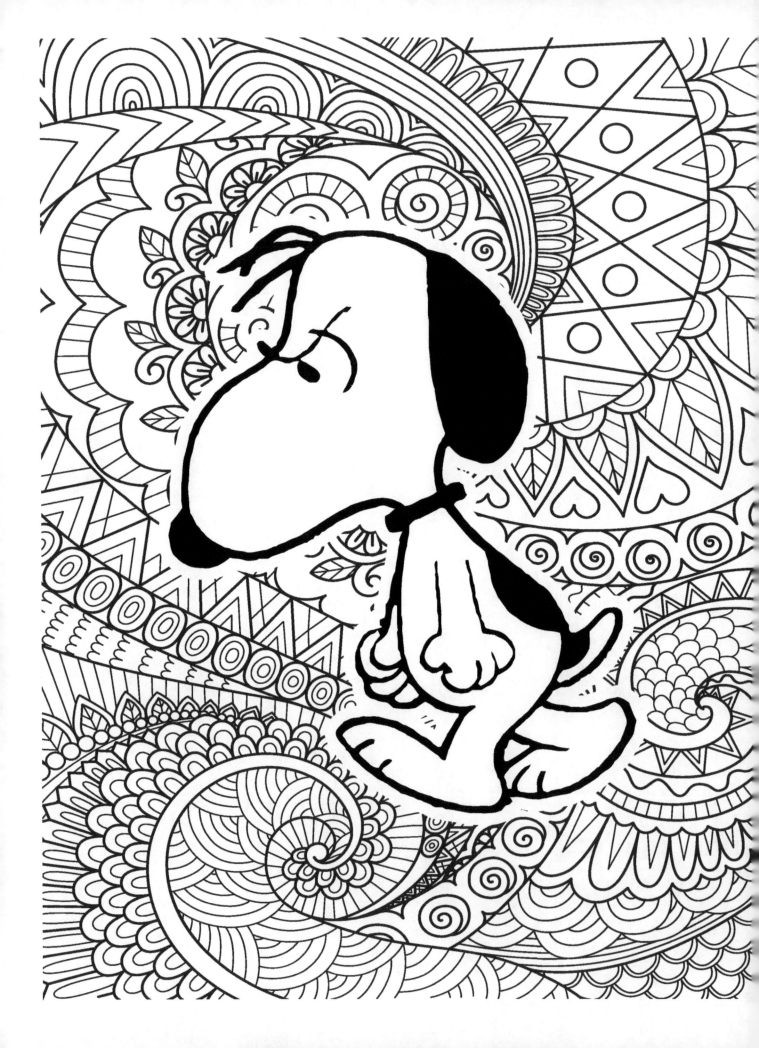

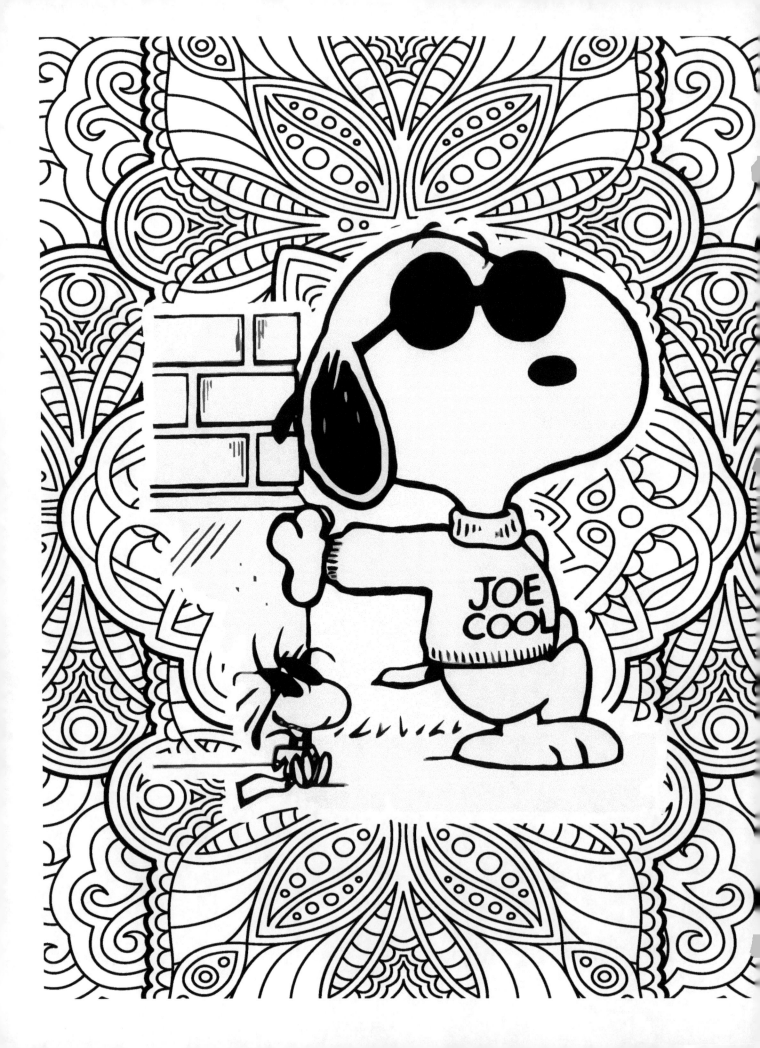

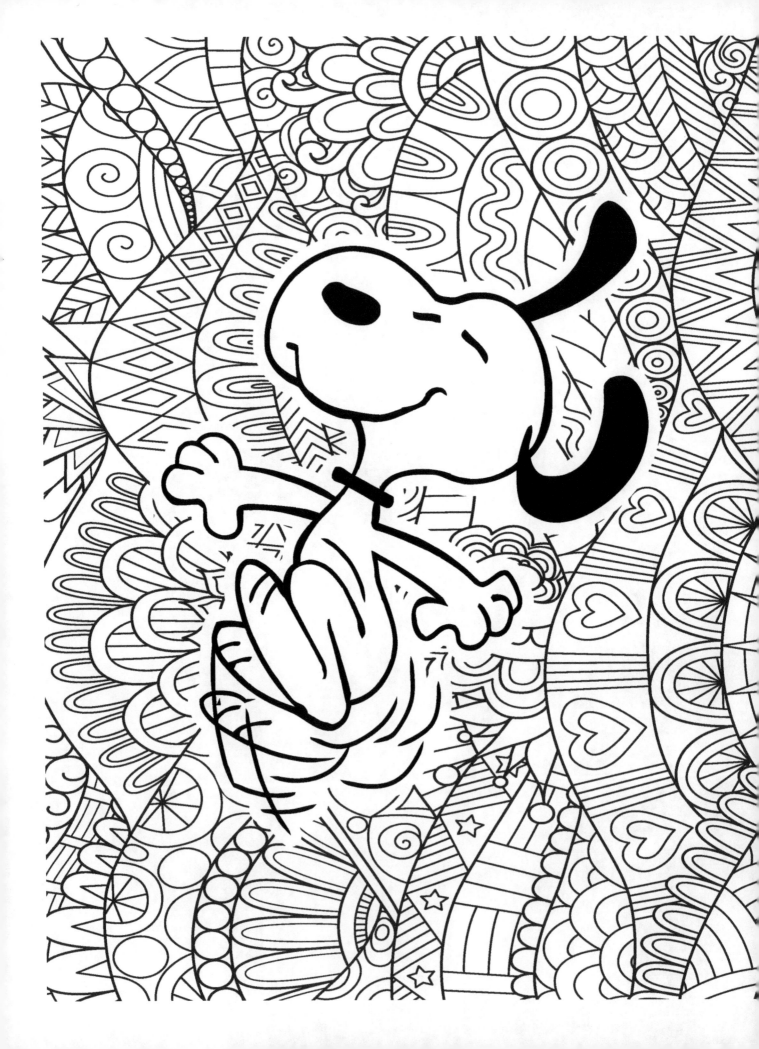

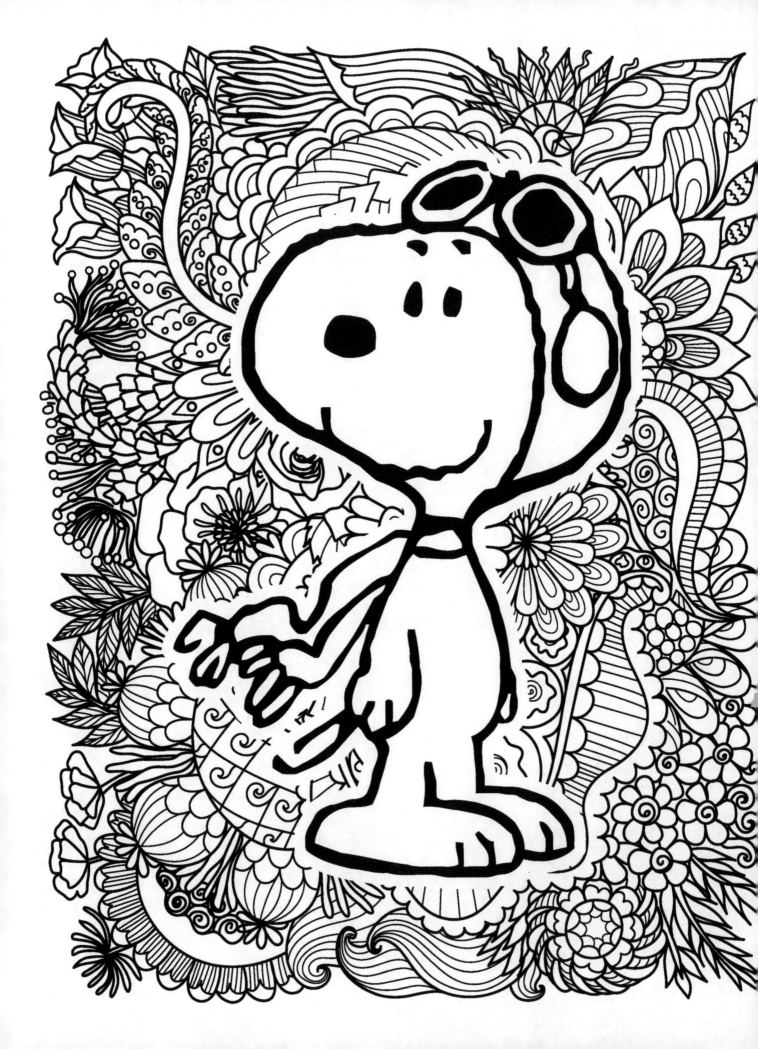

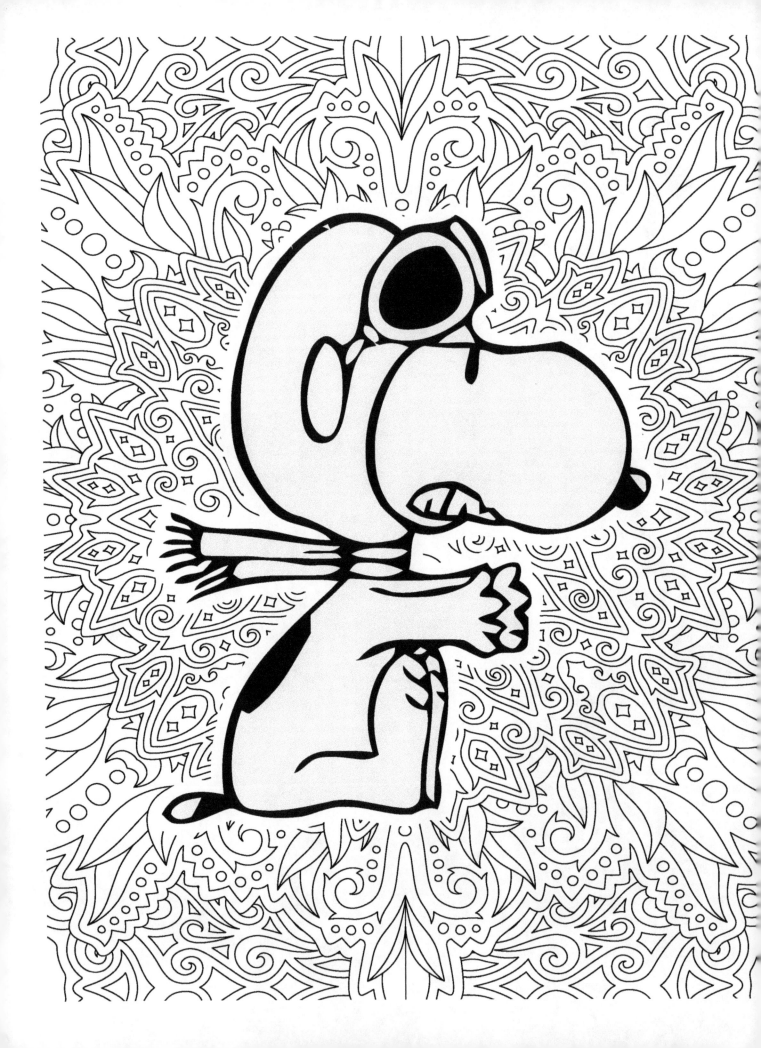

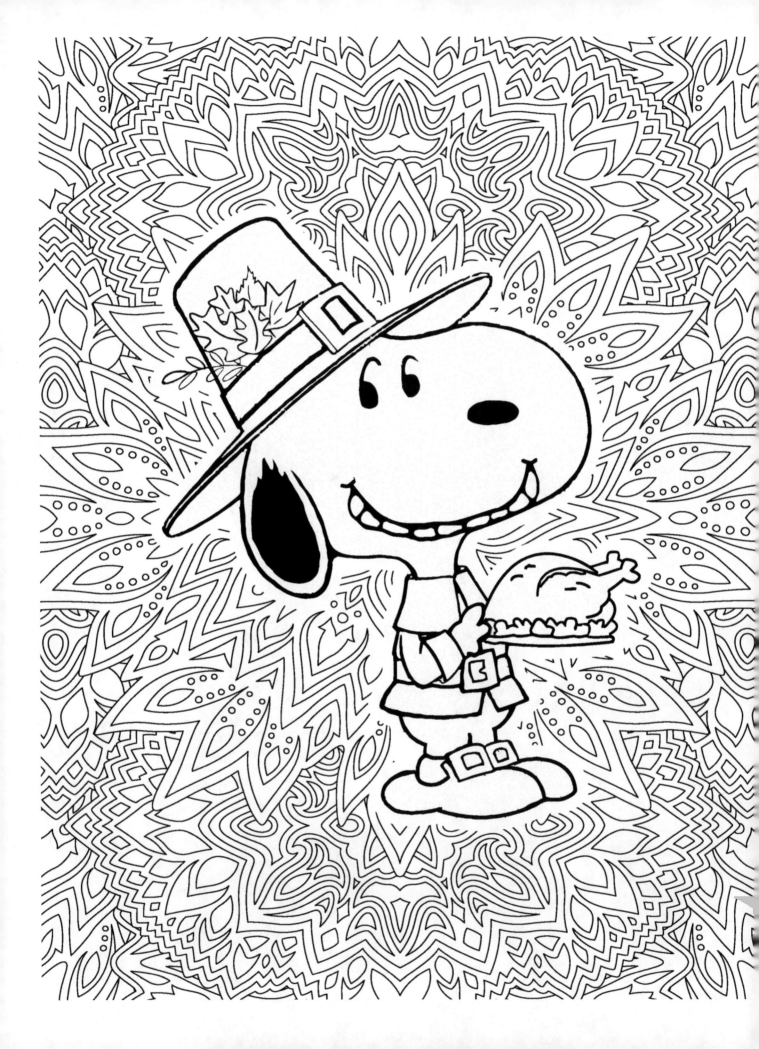

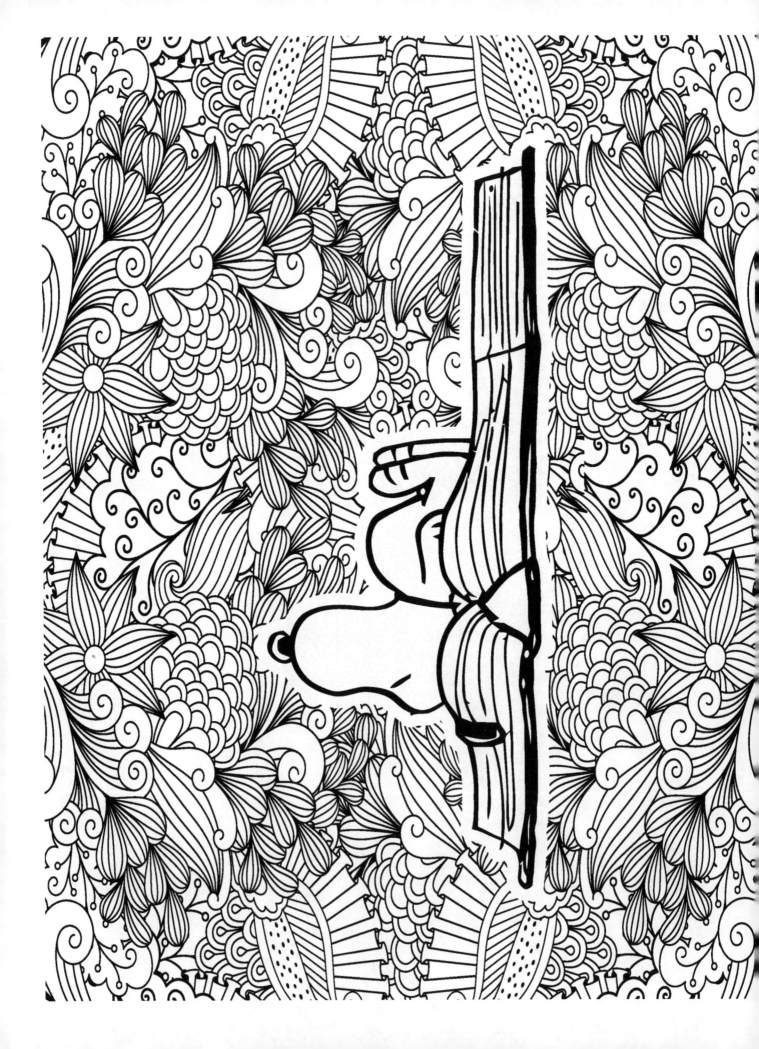

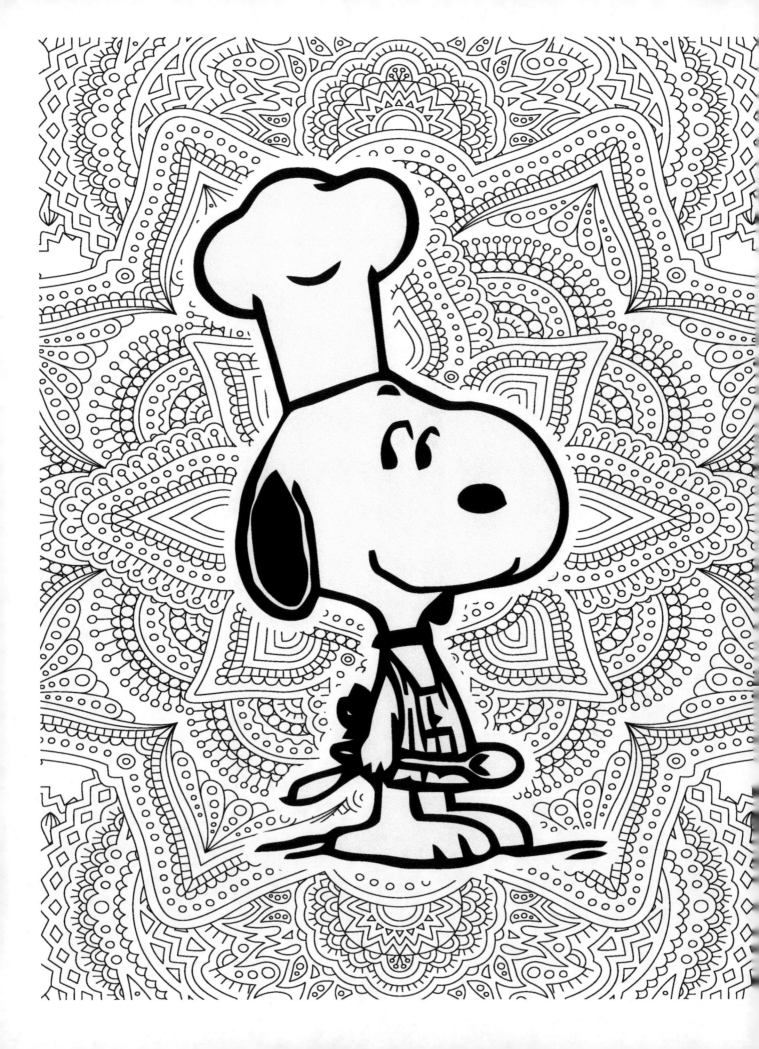

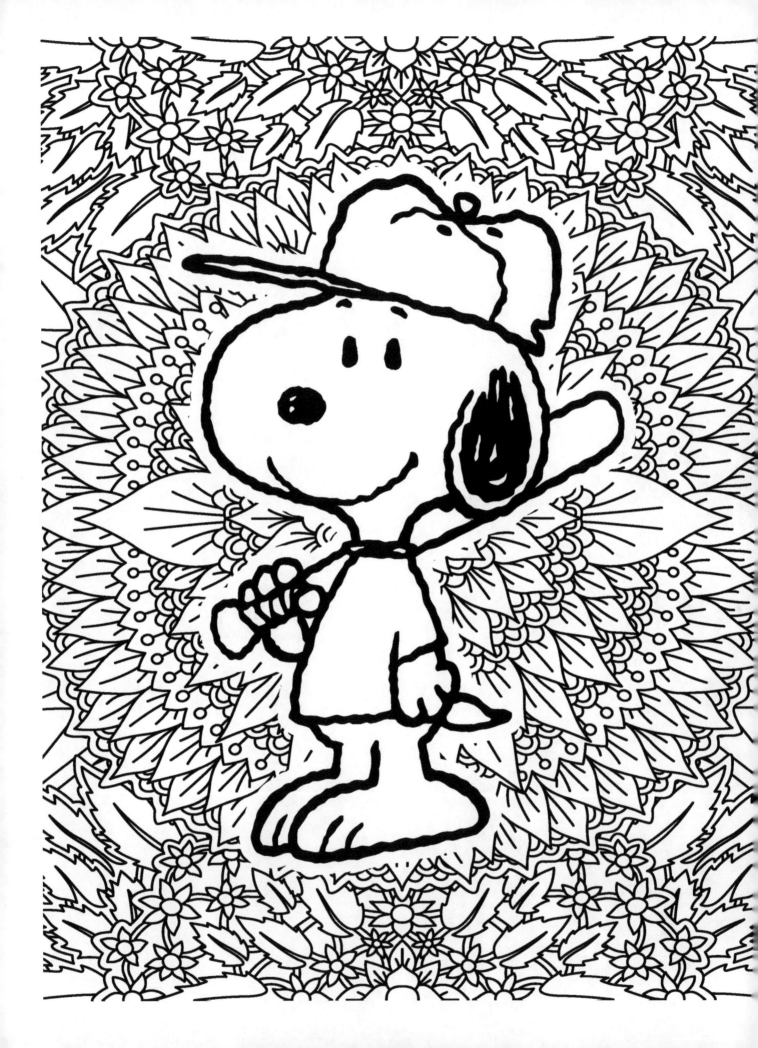

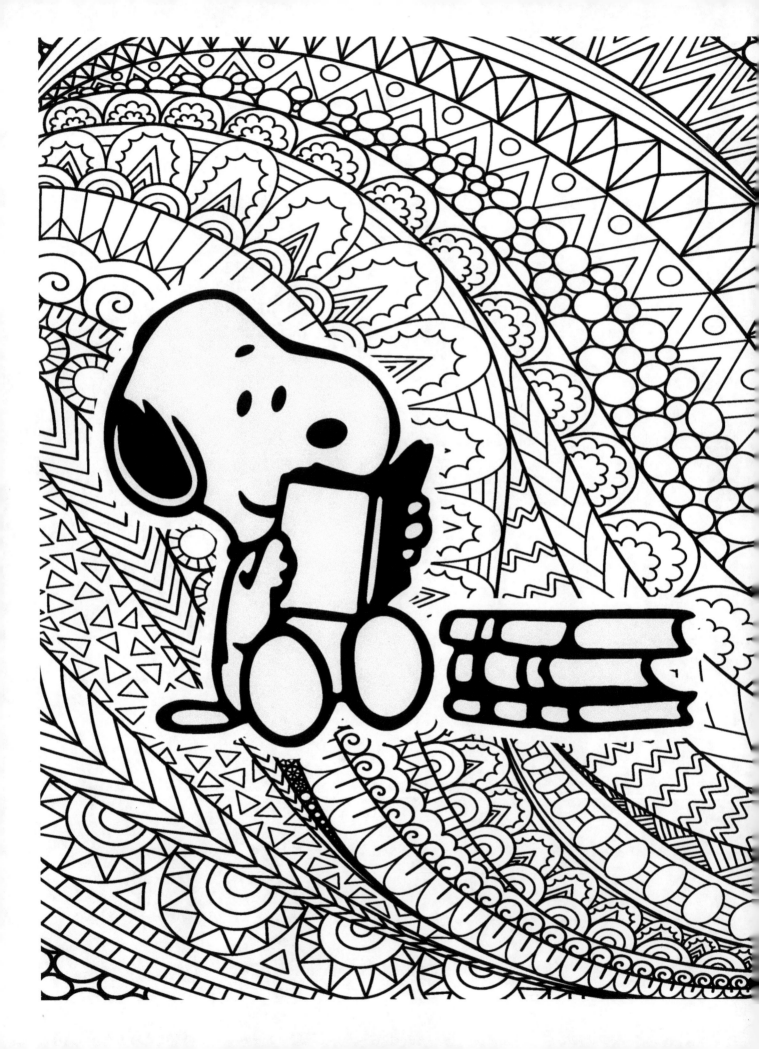

CPSIA information can be obtained
at www.ICGtesting.com
Printed in the USA
BVHW012338041121
620855BV00011BA/347